MW01405026

FATALES
The Art of Ryan Heshka

FATALES
The Art of Ryan Heshka

CERNUNNOS

To Marinda,
for immeasurable patience,
encouragement and love.

SUMMARY

6 **FOREWORD BY FRED STONEHOUSE**

10 **FUTURES PAST**

34 **SUPER BEASTS**

68 **NEO-PULP**

92 **AUTOMATONS**

112 **THE GOLDEN AGE**

152 **MEAN GIRLS**

228 **BAT-FETISH**

248 **AND BEYOND**

281 **BIOGRAPHY**

282 **INTERVIEW**

288 **CREDITS**

MYTH, MAGIC, AND MONSTROSITY: THE PAINTINGS OF RYAN HESHKA

"Remembrance of things past is not necessarily the remembrance of things as they were."
MARCEL PROUST

"We are homesick most for the places we have never known."
CARSON MCCULLERS

When I first became aware of Ryan Heshka's paintings more than ten years ago, I was immediately struck by the fact that I couldn't put my finger on a primary reason why they were so good. Sure, Ryan had a great sense of color, handled paint beautifully, managed nostalgic imagery in a highly personal and compelling way, created narratives that rode the tense edge of the absurd, etc. There were so many ingredients combined so seamlessly that no one component could be pulled out as the main one. I look at a lot of art, and I love a lot of art, but I'm not often covetous of the magic of an artist's vision. When I saw Ryan's work I wished I had made it. It was work that I could imagine having made, if I was younger, and Canadian, and had grown up as Ryan. Most artists can relate to that experience of empathy with another artist, and they will tell you that it is uncommon. Ryan's work accomplishes a sort of complex alchemy that is rare and special in contemporary art.

In my years working with and around artists, I have become aware of the fact that they operate in a few crucially different, basic ways. I believe that artists are either *Process* driven, *Conceptually* driven or *Magically* driven. I understand that most artists are involved in all three operating principles simultaneously, but they almost always lean more heavily, or even primarily towards one of these three modes. These categories may be a gross oversimplification of the complexities involved in making art, but for the purposes of this essay, they will serve.

The Process driven artist is after content that arises from an intense engagement with the process of manipulating materials. They begin by moving things around, combining materials, forms, images etc., beginning a series of considered rearrangements and manipulations; then somewhere in that activity, what they consider to be a correct and meaningful thing is arrived at. Sometimes, the Process driven artist can arrive at a finished work of art by simply applying a predetermined material process as well.

LEFT PAGE
INTO THE PALE (DETAIL)
Oil on canvas
65" x 55", 2016.

The Conceptually driven artist begins with an idea. That idea could involve anything from a consideration of politics and social consciousness to the nature of art itself. Once they have arrived at an outcome that effectively communicates their conceptual premise, they have succeeded.

The Magically driven artist operates from a deep belief in the magical power of forces in the world. These forces could be tied to any number of conditions that exist in the world, but what is crucial to this way of working is how these forces are reimagined or reoriented through the interior creative lens of a particular artist. All three ways of making art could be written about at length, but because I am looking at and thinking about the work of the painter Ryan Heshka, I will be focusing on the idea of art that is *Magically* driven.

I believe that Ryan Heshka is driven by the magical power of images from a reimagined past. I don't know this because I have never actually asked Ryan, but I suspect, that at some point in his past, he was mesmerized by the imagery of 1940s and 1950s pulp fiction, science fiction and comics. He has internalized and re-envisioned the atmosphere of that era so thoroughly that it has become the touchstone and hallmark of his art. It isn't hard to imagine Ryan coming upon this imagery in his parent's or grandparent's home, or perhaps in a used bookstore, but I am sure that it worked its way into his creative thinking and was the germ that led to the creation of his unique and wonderful universe.

Nostalgia in art is often frowned upon by critics and academics because it is seen as saccharine and false escapism, but when it is deployed skillfully, it can be transportive rather than escapist. Nostalgia might be described as a longing for a time that one believes to have been better in all the ways that matter. Ryan Heshka doesn't exactly long for a better time, rather, he actively dreams up a vision that might have been if that past had been formed more closely in line with his imagination. Many young artists engage in magical, escapist imaginings for many reasons; some to escape from painful realities, others, perhaps most others, to escape from boredom. Ryan Heshka's imagined universe is anything but boring. It is chock full of lurid drama, excitement and mind-bending adventure. When I visit Ryan's world of superheroes, giant monsters, frozen planets, femme fatales, epic disasters and a mythically re-formed Canada, I am transported to an inventive dreamland that exists in parallel with my waking reality. On the one hand, Ryan

describes a fevered, nightmarish world full of terrors, but he paints it so beautifully, he conceives it so compellingly that his audience is irresistibly drawn in. He plays on our most libidinous and voyeuristic urges to witness the psycho-sexual narrative, or the train wreck, or the thrill of being scared senseless from a horror film.

The experience of standing in front of a Ryan Heshka painting is an intimate one. Until his recent forays into large-scale, most of his paintings were quite small and required close inspection to be fully seen and digested. The sophisticated sense of materiality and his deft handling of paint make close and careful viewing satisfying in the same way that getting close to a butterfly is satisfying; beautiful from a distance, but a miracle up close. Their jewel-like object quality makes them very hard to resist. These artworks create a sense of covetousness in the viewer that is undeniable. Heshka is a masterful painter whose skills are constantly improving. In recent years his art has become more self-confident and painterly. The looser paint in his newest work does not give up an inch of descriptive eloquence, but reveals a hand that is becoming increasingly accomplished and fearless with age.

The art of Ryan Heshka is part of a contemporary wave of figurative painting that is sometimes labeled "*Pop Surrealism*" but I think that he, along with other contemporary figurative painters, looks to a broad range of sources from vernacular art forms to art history generally, and Surrealism in particular for inspiration. These artists are actively engaged in what I like to refer to as "mining the unexplored alleys" of modernism and the wide world of imagery that I refer to as the "image bank." In Modernism's rush towards aesthetic progress and the next avant-garde threshold, it left a great deal unsaid. Surrealism was only briefly explored and limited in many ways because it operated under the framework of a particular manifesto that valued the subconscious above all else. The contemporary surrealist is limited only by the breadth of their imagination, whether subconscious or otherwise. In this version of surrealism, the artist can operate as fabulist storyteller, dream interpreter, myth-maker and world-builder. This contemporary surrealism is like a vast playground whose boundaries have yet to be reached and may, in fact, be non-existent. One might look at the artworks of Ryan Heshka and think that he is way out in left field, but his project requires that he continue to search for those boundaries and the treasures that lie beyond.

Fred Stonehouse
Professor of Art
University of Wisconsin

FUTURE

S PAST

FATALES - The Art of Ryan Heshka

It's simultaneously fascinating and frustrating to know that it is impossible to experience the distant past or the far-off future. Perhaps it's for the best. It might be disappointing to know how actually depressing the Great Depression was, or terrifying to see the Earth as a burned-out cinder with a few blackened fast food signs sticking up like grave markers.

As a young, naïve child, I was oddly obsessed with the "old days"… specifically the 1930s, '40s and '50s. I did not yet know about Hitler and breadlines. I saw those decades through the lens of Hollywood on Sunday afternoons and was in awe of shiny teardrop-shaped cars racing through grand, neon-lit aluminum environs. I was infatuated with black and white, bouncing, morphing, jazz-scored animation. I collected old tins with beautifully lithographed typography. Still further back (much further), colossal reptiles and bulldog-sized insects captured my imagination. I wandered for hours through encyclopedic landscapes of prehistoric flora and fauna.

I was also completely captivated by the concepts of space travel and planetary colonization, science fiction and the utopic world of the future. Not just a push button world, but flying cars and jet packs. The Ultra-ULTRA modern. Later on, post-secondary studies turned me on to visionaries of yesterday like Frank Lloyd Wright, who believed in a better future through architecture and design.

These slivers of the past and future still inform my image creation. In my studio, the soundtracks swing from scratchy Fats Waller recordings to ambient electronic. Color swatches clipped from old magazines await new, strange combinations. Inevitably, the looming shadow of potential future environmental catastrophe enters my work from time to time. But the child in me is still holding out for that promised World of Tomorrow.

PREVIOUS DOUBLE PAGE
BOG BATTLE
Acrylic and collage on panel,
17.5" x 21", 2010.

RIGHT PAGE
SUPER SCIENTISTS
Acrylic and collage on panel,
30" x 24", 2011.

THE RAPTURE
Acrylic on panel, 12" x 24", 2008
(image courtesy of BLAB!).

TRIAL BY FIRE
Acrylic on panel, 12" x 24", 2009
(image courtesy of BLAB!).

FATALES - The Art of Ryan Heshka

FUTURES PAST

RIGHT PAGE
AGAIN
Acrylic and collage on panel, 10" x 20", 2012.

ABOVE
NOW
Acrylic and collage on panel, 10" x 20", 2012.

THE SIX
Acrylic and collage on panel,
22" x 22", 2009.

The Six

FATALES - The Art of Ryan Heshka

FUTURES PAST

RIGHT PAGE, TOP
THE PLASTIC AGE
Acrylic and collage on panel, 8" x 8", 2014.

RIGHT PAGE, BOTTOM
DADDY DIED FRIDAY NIGHT
Gouache on vintage telegram, 7" x 9", 2005.

ABOVE
THE FUTURE
Acrylic and collage on panel, 5" x 7", 2006.

Asshole

Heshka

ORIGINS OF MANITOBA

FATALES - The Art of Ryan Heshka

PREVIOUS DOUBLE PAGE, LEFT
ASSHOLE
Gouache and pencil crayon on paper, 28.5" x 20", 2016.

PREVIOUS DOUBLE PAGE, RIGHT
ORIGINS OF MANITOBA
Gouache and mixed media on paper, 7.25" x 4.75", 2015.

FUTURES PAST

LEFT PAGE

MANITOBA
Acrylic and collage on panel,
16" x 20", 2009.

ABOVE

**CANNIBALS OF
THE STONE AGE**
Acrylic and collage on panel,
8" x 8", 2012
(image courtesy of BLAB!).

27

TOP

DUPLEX

Gouache and mixed media on paper, 5.5" x 12", 2013.

ABOVE

ELECTRO PLEASURE LOUNGE

Gouache and mixed media on paper, 11" x 22", 2013.

RIGHT PAGE

THE END

Acrylic and collage on panel, 6" x 8", 2012.

FUTURES PAST

HUMANTS

Acrylic and collage on panel, 18" x 24", 2008.

FATALES - The Art of Ryan Heshka

ABOVE

THE WONDER MOUNTAIN

Acrylic and collage on board, 16.5" x 10", 2011.

RIGHT PAGE

AGO

Acrylic and collage on paper, 34" x 36", 2011.

FUTURES PAST

33

SUPER

BEASTS

For as long as I can remember, I have taken great pleasure flipping over rocks at the beach or in abandoned lots in the hopes of seeing something revolting or slimy crawl out from underneath. I find nature's version of "creepy" to be beautiful and hypnotic. The more legs and eyes, the better.

As a child I wasn't satisfied with merely creepy: I needed size. Drawings and movies made in my youth reveal enormous spiders devouring buildings and stop-motion, train-car sized scorpions pinching people in half. Living in a pre-VHS world, I had to mostly imagine what the movie monsters of the 1950s I'd read about actually looked like. It turned out that sketching what I'd imagined was more rewarding than the often-disappointing reality of a man in a rubber costume. There were, however, some films in which the loathsome stars were inspired and memorable. These include the creations of stop motion wizard Ray Harryhausen, whose incredible dedication to his craft inspired in me not only behemoth-oriented imagery but also a focused work ethic. The Atomic Age movie *THEM!* featuring 12-foot long hydraulic, shaggy, mutated ants gave me giant insect fever. Roger Corman's zoo of low budget drive-in leviathans showed me the brutal appeal of the B-movie.

Seeing the proliferation of contemporary creatures, it feels like we have lost some of the wonderment and mystery of the monster to the slickness of CGI. There is nothing left to our imaginations. Maybe the beasts of pop culture past had actual personalities because they were often created and/or controlled by one person, with that person's ego and quirks subtly conveyed on screen without their knowledge. But whether they came from outer space, beneath the sea, or Hell itself, I have always liked the idea of a latex-and-wire monstrosity that was able to, at least temporarily, put humans in their place.

PREVIOUS DOUBLE PAGE
MILWAUKEE 1941
Acrylic and collage on panel,
10" x 18", 2008.

RIGHT PAGE
SCIENTIST REVOLUTION
Acrylic and collage on panel,
14.5" x 11.5", 2007.

TOP
WALL STREET ZOMBIES!
Acrylic and collage on panel, 6.25" x 9", 2013 (image courtesy of BLAB!).

LEFT
FEAR
Acrylic and collage on panel, 8" x 8", 2006 (image courtesy of BLAB!).

RIGHT PAGE
ULTRA POWER TWINS
Gouache and mixed media on paper, 7" x 5", 2013.

NEXT DOUBLE PAGE
SEAFOOD REVOLT
Acrylic and mixed media on panel, 26" x 36", 2012.

SEAFOOD REVOLT

PREVIOUS DOUBLE PAGE
THE FANTOM WIG
Gouache and mixed media on paper, 9.5" x 16", 2013.

ABOVE
SEA QUEEN
Acrylic and collage on board, 9.5" x 7.5", 2010.

TAKES BOYS AWAY
Acrylic and collage on board,
4.5" x 3.5", 2012.

WITH SUPER DRUGS
Acrylic and collage on panel, 18" x 24", 2009.

FATALES - The Art of Ryan Heshka

THIS PAGE

DOCTOR WORM

Gouache and mixed media on paper, 4" x 3.5" (each panel), 2006.

RIGHT PAGE

NEON QUEEN

Gouache and mixed media on paper, 9" x 7", 2007.

SUPER BEASTS

NEON QUEEN

49

WHEN YOU'VE EATEN UNWISELY

Acrylic and collage on panel,
8" x 8", 2011.

BLAB! #18 COVER
Acrylic and collage on panel, 12" x 12", 2007 (image courtesy of BLAB!).

FATALES - The Art of Ryan Heshka

SUPER BEASTS

Land Fish Attack

LEFT
YOUR WAR
Acrylic and collage on panel,
22" x 10", 2007.

ABOVE
LAND FISH ATTACK
Acrylic and collage on panel,
18" x 24", 2010.

ABOVE
TERROR
Acrylic and collage on board,
14" x 11", 2009.

RIGHT PAGE
CREEPER
Acrylic and collage on board,
12" x 9", 2007.

WINGS OF GLASS
Acrylic and collage on panel,
16" x 20", 2010.

WINGS OF GLASS

Heshka

FATALES - The Art of Ryan Heshka

SUPER BEASTS

IT'S **GLANDULAR**

PREVIOUS DOUBLE PAGE, LEFT

ATOMIC AGE VAMPIRES
Acrylic and collage on panel,
12" x 9", 2012.

PREVIOUS DOUBLE PAGE, RIGHT

IT'S GLANDULAR
Gouache on paper,
15.5" x 15.5", 2011.

SUPER BEASTS

LEFT PAGE

FOR MEN

Acrylic and collage on panel,
12" x 12", 2009
(image courtesy of BLAB!).

ABOVE

NEW PROBLEMS

Acrylic and collage on panel,
12" x 12", 2007
(image courtesy of BLAB!).

NEXT DOUBLE PAGE

GARDEN OF TORMENT

Acrylic and collage on panel,
22" x 30", 2010.

GARDEN of TORMENT

SUPER BEASTS

DEATH clouds

65

FATALES - The Art of Ryan Heshka

PREVIOUS DOUBLE PAGE, LEFT
SUBHUMAN
Acrylic and collage on board, 6" x 6.5", 2008.

PREVIOUS DOUBLE PAGE, RIGHT
DEATH CLOUDS
Gouache and mixed media on paper, 9.5" x 7.5", 2008.

TOP
SUBHUMANS
Acrylic and collage on board, 5.5" x 4.5", 2014.

LEFT
DOCTORS STORIES
Acrylic and collage on panel, 10" x 10", 2008.

RIGHT PAGE
3D ELECTRO TELEVISION SCREEN
Acrylic and collage on panel, 17" x 12", 2007.

ELECTRO TELEVISION **screen**

NEO-

PULP

PREVIOUS DOUBLE PAGE
PLEASURE PLANET
Acrylic and collage on panel,
20" x 28", 2010.

RIGHT PAGE
ROMANCE OF CANADA
Acrylic and collage on panel,
16" x 20", 2015.

Pulp magazines. Dime novels. Literature's lurid half-sibling from the early 20th century. This cheap form of entertainment died off over 60 years ago, yet its blood-soaked ghost continues to serve as a muse for modern day artists, writers, and filmmakers. Certainly, this must be due at least in part to the strength of the undiluted cover images that sold these abominable anthologies.

My first "sense of wonder" pulp moment came on Christmas in the late 1970s when I received a "Making of Star Wars" book. One of the images in the book was a typical example of pulp art that inspired George Lucas: the December 1926 cover of *Amazing Stories*, featuring an illustration by Frank R. Paul. It was an imaginative landscape featuring winged nude women, who watched as a giant magnetic globe floated an ocean liner through the sky. I had no context for the story, but it didn't matter: I was sold. Paul quickly became a favorite of mine (and remains so to this day), and through his work I discovered an art form full of raw energy, intensity, grit, and awe.

The best pulp artists like Norman Saunders and Margaret Brundage beautifully defined that depression era aesthetic with which I have long been obsessed. They captured *and* created the best qualities of film noir, science fiction, and fantasy, and exhibited masterful (or at least eye-catching) painting techniques. There was an incredible verve inherent to pulp art, and also a confidence: nothing hesitant or apologetic about a pulp cover. Broad, quick strokes of ink and paint applied with all the two-fisted subtlety of the subjects.

The continued attempt to distill the pulp language and apply its relevant principles remains an ongoing process for me. I now rely less on typical pulp visuals, instead focusing on the pulp "spirit": freezing the vitality of an idea, injecting it with life, while still leaving something to the viewer's imagination. It is the conjuring of and contact with a dead art form.

FATALES - The Art of Ryan Heshka

ABOVE, LEFT

GUILT

Acrylic and collage
on board, 6" x 4", 2006.

ABOVE, RIGHT

AMP

Acrylic and collage
on board, 8" x 6", 2007.

RIGHT PAGE

VANDALS FROM THE VOID

Acrylic and collage
on panel, 9" x 6.25", 2013
(image courtesy of BLAB!).

72

NEO-PULP

VANGUARDS FROM THE VOID

FATALES - The Art of Ryan Heshka

FATALES - The Art of Ryan Heshka

PREVIOUS DOUBLE PAGE, LEFT
MYSTERY TWINS
Acrylic and collage
on board, 6" x 4", 2012.

PREVIOUS DOUBLE PAGE, RIGHT
PLEASE HOLD
Acrylic and collage
on board, 4.5" x 3.5", 2012.

ABOVE
NOW! SECRET DELIVERY
Acrylic and collage
on board, 4.25" x 3", 2012.

RIGHT PAGE
LOVE, RADIO, DRUGS AND MONEY
Acrylic and collage
on board, 5" x 4", 2012.

LOVE, RADIO, DRUGS and Money

10¢

Heshka

No. 1

ABOVE
DYNAMIC
Acrylic and collage on panel,
16" x 12", 2009.

RIGHT PAGE
OURS
Acrylic and collage on board,
5" x 4", 2012.

NEXT DOUBLE PAGE, LEFT
LUXE
Acrylic and collage on panel,
16" x 12", 2007.

NEXT DOUBLE PAGE, RIGHT
SPACE SIRENS
Oil on panel,
24" x 16", 2016.

Ours

YOURS AND MINE

✚ luxe ✚

NEO-PULP

ABOVE

MYSTERIOUS ALL–ELECTRIC EYES
Acrylic and collage on board, 6" x 3", 2014.

RIGHT

SCIENCE POWER PICTURE
Acrylic and collage on board, 6" x 3", 2014.

NEO-PULP

ABOVE

FACTORY MICROSCOPE LABORATORY

Acrylic and collage on panel, 34" x 20", 2011.

RIGHT

PUBIC SPY

Oil on panel, 14" x 6", 2015.

83

PREVIOUS DOUBLE PAGE, LEFT
NEXT TIME SAFETY!
Gouache and mixed media on paper, 7" x 5.5", 2013.

PREVIOUS DOUBLE PAGE, RIGHT
CULT LIFE
Acrylic and collage on board, 5" x 3.5", 2012.

TOP
ORGAN ROBBERY
Acrylic and collage on board, 4" x 11", 2012.

LEFT
ZERO
Acrylic and collage on board, 13" x 10", 2007.

RIGHT PAGE
INSTINCTION
Acrylic and collage on panel, 20" x 16", 2011.

FATALES - The Art of Ryan Heshka

TOP
THE FLOATING
Oil on panel, 10" x 12", 2015.

RIGHT PAGE
THE THING
Oil on panel, 12" x 9", 2015.

88

NEO-PULP

FATALES - The Art of Ryan Heshka

TOP

SHORT WAVE DEATH

Acrylic and collage on panel,
10" x 10", 2008
(image courtesy of BLAB!).

RIGHT PAGE

SEE

Acrylic and collage on panel,
20" x 12", 2007.

AUTOM

ATONS

The 1970s were a great time to be a robot-obsessed child. Robots starred in movies, comic books, and TV shows. The toy market was loaded with all shapes and sizes of wind up, light-up, battery operated mechanical beings. Nerds were rising up secretly in basements and garages, about to take robots to the next level. Robots were transitioning from celluloid to daily life, for better or worse.

I never had much interest in humanized robots, or androids: robots trying to pass for one of us. First, they couldn't be trusted, and second, they looked boring. My robotic brand was and is the variety that resembles a tower of colorful metal bricks, a lumbering tonnage of industrial design. A Raymond Lowey fever dream speaking in tinny, clicking monotones.

Even less interesting to me is the portrayal of robots as our benefactors. Technology-gone-berserk always struck me as a much more appealing subject matter, and maybe a more likely outcome. By contrast, if the machines are not running rampant in my paintings, they are placed in settings where they coexist harmoniously with nature but with humans conspicuously absent, almost as if robots and nature have struck a perfect balance, both realizing that our soft, needy species has no place in the grand, beautiful scheme of the universe.

My own love/hate relationship with technology increasingly seeps into these images. The Luddite in me longs for the innocence of the spring-wound, pocket-sized mechanical bipeds. Are we being groomed to be totally, absolutely reliant on our digital diet? Will we be a world of addicted, swiping, trolling junkies? As an artist I can't help but distrust the pervasiveness of modern technology, that somehow the shiny seductiveness that currently captivates us is becoming our master in ways we haven't yet imagined.

PREVIOUS DOUBLE PAGE
PLASTIC RADIO MASTER NO. 1 (DETAIL)
Acrylic and collage on panel,
20" x 16", 2010.

RIGHT PAGE
ICE
Acrylic and collage on board,
8" x 6", 2006.

ICE

1

ONLY $12.95

Through The Ice

TOP
ROBOT TWINS
Gouache and mixed media on paper, 8" x 10", 2005.

ABOVE
PREHYSTERIA
Gouache and mixed media on paper, 8" x 10", 2004.

AUTOMATONS

TOP
RADIO EYE
Gouache and mixed media on paper. 10.5" x 12.5", 2008.

ABOVE, LEFT
RED ROBOT
Gouache and mixed media on paper, 6" x 4.5", 2005.

ABOVE, RIGHT
ELIZABETH
Gouache and mixed media on paper, 6" x 4.5", 2005.

FATALES - The Art of Ryan Heshka

TOP, LEFT

GREEN ROBOT
Gouache and mixed media on paper, 7.5" x 6", 2005.

TOP, RIGHT

THE CONQUEROR
Gouache and mixed media on paper, 17" x 12", 2009.

BOTTOM, LEFT

FEAR ROBOT
Gouache and mixed media on paper, 7.5" x 6", 2005.

BOTTOM, RIGHT

PTERODACTYL DEATH MATCH
Gouache and mixed media on paper, 7" x 5", 2007.

RIGHT PAGE

PHANTOM TELEVISOR
Gouache and mixed media on paper, 8" x 6.5", 2005.

AUTOMATONS

RIGHT PAGE

RADIO GUITARS

Acrylic and collage
on board, 6" x 5", 2006.

RIGHT PAGE

MEDICAL RAY VIBRATION

Acrylic and collage on panel,
16" x 20", 2009.

AUTOMATONS

Medical Ray Vibration

MEDICATED ROBOT
Acrylic and collage on board,
8" x 10", 2012.

medicated ROBOT

CASE 01101

FATALES - The Art of Ryan Heshka

Filme

5¢ EACH

Ace Newsreel Cameraman

SEP 13 '39

Poison Bat Movie

PREVIOUS DOUBLE PAGE, LEFT
ROBOTUS DELUXE NO.3
Acrylic and collage on board,
6.75" x 4.75", 2008.

PREVIOUS DOUBLE PAGE, RIGHT
FILME
Acrylic and collage on board,
7" x 4.5", 2006.

TOP
RADIO VIBRATORS
Acrylic and collage on panel,
12" x 12", 2005.

RIGHT PAGE
ELECTRONIC REVOLT
Acrylic and collage on board,
13" x 10", 2010.

AUTOMATONS

10 CENTS

ION 02

ELECTRONIC REVOLT

FATALES - The Art of Ryan Heshka

AUTOMATONS

★ WOODLAND RESCUE ★

SAVE

SAVE

$1

Heshka

109

PREVIOUS DOUBLE PAGE, LEFT

ELECTRO–VOICE
Acrylic and collage on panel,
16" x 10", 2005.

PREVIOUS DOUBLE PAGE, RIGHT

WOODLAND RESCUE
Acrylic and collage on panel,
9" x 6.25", 2011
(image courtesy of BLAB!).

110

ABOVE

KEEP AMERICA FREE
Acrylic and collage on panel,
12" x 24", 2008
(image courtesy of BLAB!).

THE GOL

DEN AGE

FATALES - The Art of Ryan Heshka

THE GOLDEN AGE

PREVIOUS DOUBLE PAGE
HYPNOTO
Acrylic and collage on panel,
6.25" x 9", 2011
(image courtesy of BLAB!).

LEFT PAGE
IN OUTER SPACE CAVERNS
Acrylic and collage on board,
4.75" x 4.25", 2008

The comic book has always held unlimited inspiration for me. But early on, I got hooked on a very specific comic drug: the Golden Age comic. "Golden age" refers to that period between the late 1930s and mid-1950s when comic books flourished like four-color weeds in American culture. Its bright beginnings with Superman were almost snuffed out with the mass burning of "evil" comics in the McCarthy era.

This dawning era of the superhero revealed itself to me through reprint material, and I was immediately drawn to and intrigued by this period of comics I did not know had existed. I was enamored with the crude work of artists who lacked the skills to break into the world of big-money newspaper strip syndication. I was intrigued by the weird, dark quality of a Bill Everett *Submariner* strip much more than the slick sophistication of Alex Raymond's *Flash Gordon*. The comic book was in its infancy in that post-Depression America, and the results were a dynamic art form produced by excited, youthful, impoverished daydreamers. There was no editorial standard or censorship to answer to, and they pushed their imaginations (and good taste) to the limits.

Of course, most of what was produced was terrible. But out of the heap, artists liked Tarpé Mills, Basil Wolverton, and Fletcher Hanks continually caught my attention. There were many such auteurs that created some of the most unique work in the medium. I began to see lone panels removed from the context of the story, creating potential for an imagined, mysterious narrative (later learning about Lichtenstein). The crudeness of the line work was no longer perceived as clunky and unskilled, but rather an honest mark made by unselfconscious artists. Looking past the black lines of the artwork revealed wondrous relationships of four-color shapes and forms.

The pure beauty of old comics is like that of the folk artist or *art brut*: individual, sometimes innovative mark making. That honesty and enthusiasm have set the bar for my art career. I have been chasing that paper dragon's tail ever since.

FATALES - The Art of Ryan Heshka

ABOVE

**TWO-WAY DANGER
(MADAM BLUD)**

Acrylic and collage on panel, 10" x 10", 2008 (image courtesy of BLAB!).

RIGHT PAGE

WORMOSCOPE

Acrylic and collage on panel, 9" x 6.25", 2010 (image courtesy of BLAB!).

116

FATALES - The Art of Ryan Heshka

The COUNT GREEBLY

THE GOLDEN AGE

LEFT PAGE

THE COUNT GREEBLY

Acrylic and collage on panel, 9" x 6.25", 2011 (image courtesy of BLAB!).

ABOVE

THE MAN RAY

Acrylic and collage on panel, 6.25" x 9", 2011 (image courtesy of BLAB!).

FATALES - The Art of Ryan Heshka

TOP
ENTER THE CREEPER
Acrylic and collage on panel, 6.25" x 9", 2011 (image courtesy of BLAB!).

RIGHT PAGE
NIGHT OF FEAR
Acrylic and collage on panel, 9" x 6.25", 2011 (image courtesy of BLAB!).

120

THE GOLDEN AGE

NIGHT OF FEAR!

121

FATALES - The Art of Ryan Heshka

The HAUNTED CLOSET

THE GOLDEN AGE

PREVIOUS DOUBLE PAGE, LEFT
HAUNTED CLOSET
Acrylic and collage on panel, 9" x 6.25", 2011 (image courtesy of BLAB!).

PREVIOUS DOUBLE PAGE, RIGHT
THE INFECTO ARMY
Acrylic and collage on panel, 9" x 6.25", 2011 (image courtesy of BLAB!).

ABOVE
WONDERS OF THE GOLDEN AGE
Acrylic and collage on panel, 10" x 20", 2008 (image courtesy of BLAB!).

NEXT DOUBLE PAGE, LEFT

SELECTED COMICS #1

Acrylic and collage on panel, 14" x 11", 2008.

NEXT DOUBLE PAGE, RIGHT

MARVEL WOMAN

Gouache and mixed media on paper, 9" x 7", 2007.

Selected
comics

No. 1
35 CENTS

DEC 05 1939

IN THIS ISSUE
ANTI-FREEZE

THE GOLDEN AGE

Marvel woman

FATALES - The Art of Ryan Heshka

THE GOLDEN AGE

129

PREVIOUS DOUBLE PAGE, LEFT
ULTRA FINE
Gouache and mixed media on paper, 8" x 6", 2008.

PREVIOUS DOUBLE PAGE, RIGHT TOP
THE HEROES TIRE
Gouache and mixed media on paper, 10" x 15", 2009.

PREVIOUS DOUBLE PAGE, RIGHT BOTTOM
GEE 603
Gouache and mixed media on paper, 10" x 12", 2008.

TOP
HEROES OF TOMORROW
Acrylic and collage on panel, 10" x 10", 2008
(image courtesy of BLAB!).

RIGHT PAGE
HYPNO MYSTERIES NO.2
Acrylic and collage on board, 15" x 12", 2008.

SEPTEMBER, 1932

HYPNO
mysteries

2 only 10¢

VERSUS

FATALES - The Art of Ryan Heshka

THE GOLDEN AGE

THE ORGAN-ISM!

FATALES - The Art of Ryan Heshka

PREVIOUS DOUBLE PAGE, LEFT

HEADLESS CULT
Acrylic and collage on panel, 9" x 6.25", 2011 (image courtesy of BLAB!).

PREVIOUS DOUBLE PAGE, RIGHT

THE ORGAN–ISM!
Acrylic and collage on panel, 9" x 6.25", 2011 (image courtesy of BLAB!).

TOP

THE DEAD WHITE THING
Acrylic and collage on panel, 6.25" x 9", 2013 (image courtesy of BLAB!).

RIGHT PAGE

THE CREEPER
Acrylic and collage on panel, 20" x 16", 2010.

134

THE GOLDEN AGE

ABOVE, LEFT

HORROR HOSPITAL

Acrylic and collage on panel, 9" x 6.25", 2013 (image courtesy of BLAB!).

ABOVE, RIGHT

THE TERRIBLE TRANSPLANT

Acrylic and collage on panel, 9" x 6.25", 2013 (image courtesy of BLAB!).

RIGHT PAGE

THE UNHOLY GARDEN

Acrylic and collage on panel, 9" x 6.25", 2013 (image courtesy of BLAB!).

136

THE UNHOLY GARDEN

FATALES - The Art of Ryan Heshka

TOP

FOUR DIMENSIONAL ABDUCTION

Oil and collage on panel, 14" x 11", 2013.

RIGHT PAGE

LOOK... LEARN

Acrylic and collage on board, 5" x 4", 2012.

138

Look... Learn

TOP
DON'T BE A PRICK
Gouache on vintage daytimer,
5.25" x 5.25", 2007.

RIGHT PAGE
MYTH OF THE BLUE CARIBOU
Acrylic and collage on board,
7.5" x 5.5", 2015.

MYTH of The

BLUE CARIBOU

FATALES - The Art of Ryan Heshka

142

PREVIOUS DOUBLE PAGE, LEFT
BEHE-MOTH
Acrylic and collage on panel, 9" x 6.25", 2013 (image courtesy of BLAB!).

PREVIOUS DOUBLE PAGE, RIGHT
MAN-MADE MANIACS
Acrylic and collage on panel, 9" x 6.25", 2013 (image courtesy of BLAB!).

LEFT PAGE
DETECTO
Acrylic and collage on board, 5.75" x 4.75", 2008.

ABOVE
THE MELTING GAZE
Acrylic and collage on panel, 6.25" x 9", 2013 (image courtesy of BLAB!).

FATALES - The Art of Ryan Heshka

THE LURE 2

SELKIRK, MANITOBA

FATALES - The Art of Ryan Heshka

THE GOLDEN AGE

PREVIOUS DOUBLE PAGE, LEFT
THE LURE
Oil and collage on panel, 18" x 14", 2015.

PREVIOUS DOUBLE PAGE, RIGHT
MIDGET VAMPIRE COMIC
Acrylic and collage on board, 4" x 2.25", 2013.

LEFT PAGE
SUPERV
Acrylic and collage on board, 7" x 5", 2012.

ABOVE
THE CREEPER LURKS!
Acrylic and collage on panel, 6.25" x 9", 2010 (image courtesy of BLAB!).

149

TOP

THE SECRET SYNDICATE

Acrylic and collage on panel, 10" x 10", 2008 (image courtesy of BLAB!).

RIGHT PAGE

UP YOURS

Acrylic and collage on panel, 8" x 8", 2007.

THE GOLDEN AGE

151

MEAN

GIRLS

FATALES - The Art of Ryan Heshka

Women have had a prominent starring role in my art over the last two decades. Specifically, and unapologetically, women inspired by and wrapped in satiny old-school Hollywood glamour. There is an irresistible lure in the bold presence of silver screen powerhouses like Barbara Stanwyck or Lauren Bacall. The kaleidoscopic choreography of Busby Berkeley. Shadowy femme fatales forever skulking in dark alleys and on foggy waterfronts. And in the comics: Wonder Woman, Madam Satan, and the Catwoman.

My subjects moved quickly from damsels in distress to damsels *inflicting* distress. Females that radiate strength, celebrating their beauty and power and sexuality and control. This culminated in my *Mean Girls Club* installation, where six pencil-skirted bad-asses came to life in a comic book, a short film, silk-screen posters, murals, and a life-size build-out of their pink and black clubhouse. Less confrontational but more alluringly enigmatic are the *Mystery Twins*: a series of strange masked Doppelgängers engaged in everything from alchemy to ice fishing.

Although still an admirer of the art deco-esque sculptural, swooping hair, the slinky silk dresses and patent leather heels of the past, lately my interests have strayed from that classic celluloid type of beauty. Less Veronica Lake and more Lake Eerie. As with other genres I'm captivated with, I continually attempt to move away from the traditional, the obvious, and explore beneath the skin.

Over the course of my career, my artwork has evolved from crowded scenes of small, clone-like women, to larger studies of one or two figures, and finally to more intimate, close-up portraits. Without being aware of it, I have approached these painted members of the fairer sex with extreme caution.

PREVIOUS DOUBLE PAGE
SEDUCTION OF MARVA
Acrylic and collage on panel,
6.25" x 9", 2010
(image courtesy of BLAB!).

RIGHT PAGE
LUXURIES OF THE PAST
Acrylic and collage on board,
5" x 4", 2013.

Luxuries

10¢

OF THE PAST

TOP, LEFT
ELECTRICAL WITCHES
Gouache and mixed media on paper, 5" x 3", 2015.

TOP, RIGHT
ICE FISHING FOREVER
Gouache and mixed media on paper, 5" x 3", 2015.

BOTTOM, LEFT
STENOGRAPHY X
Gouache and mixed media on paper, 5" x 3", 2015.

BOTTOM, RIGHT
KEEP OUT
Gouache and mixed media on paper, 5" x 3", 2015.

RIGHT PAGE
EXTRA FRESH FUTURIST SOCIETY
Gouache and mixed media on paper, 5" x 3", 2015.

MEAN GIRLS

Best Wishes from

EXTRA FRESH
FUTURIST SOCIETY

Heshka

FATALES - The Art of Ryan Heshka

MEAN GIRLS

LEFT PAGE
THE CAUSE
Gouache and mixed media on paper, 5" x 3", 2015.

TOP, LEFT
THE SUPER TWINS
Gouache and mixed media on paper, 5" x 3", 2015.

TOP, RIGHT
YOUR MOVE
Gouache and mixed media on paper, 5" x 3", 2014.

BOTTOM, LEFT
DRUGS AND MAKE–UP
Gouache and mixed media on paper, 5" x 3", 2015.

BOTTOM, RIGHT
QUIET PLEASE
Gouache and mixed media on paper, 5" x 3", 2014.

FATALES - The Art of Ryan Heshka

TOP, LEFT
SUPER DELUXE ACCIDENT
Gouache and mixed media on paper, 5" x 3", 2015.

TOP, RIGHT
MARVELADY
Gouache and mixed media on paper, 5" x 3", 2012.

BOTTOM, LEFT
THE DON'T CORPORATION
Gouache and mixed media on paper, 5" x 3", 2015.

BOTTOM, RIGHT
3-DIMENSIONAL BI-POLAR ROBOT TELEPHONE GIRL
Gouache and mixed media on paper, 6" x 4", 2012.

RIGHT PAGE
THE MAGICIAN
Gouache and pencil crayon on paper, 15" x 11", 2016.

160

THE MAGICIAN

FATALES - The Art of Ryan Heshka

SHARESIES

MEAN GIRLS

LEFT PAGE

SHARSIES

Gouache and mixed media on paper, 5" x 3", 2013.

TOP, LEFT

THE CANADIAN CALLBOX

Gouache and mixed media on paper, 7.25" x 4.75", 2015.

TOP, RIGHT

MISS CANADIANA

Gouache and mixed media on paper, 7.25" x 4.75", 2015.

BOTTOM, LEFT

WINNIPEG WOMEN WONDER AGENCY

Gouache and mixed media on paper, 5" x 3", 2015.

BOTTOM, RIGHT

DOUBLE POWER BUBBLES

Gouache and mixed media on paper, 5" x 3", 2013.

163

FATALES - The Art of Ryan Heshka

ABOVE, LEFT
GIRL C
Gouache and mixed media on paper, 5.5" x 3.5", 2016.

ABOVE, RIGHT
GIRL B
Gouache and mixed media on paper, 5.5" x 3.5", 2016.

RIGHT PAGE
GIRL A
Gouache and mixed media on paper, 5.5" x 3.5", 2016.

THEY BROUGHT US HERE

Acrylic and collage on paper,
30" x 60", 2011.

Us Here

LEFT

MEET FROG WIFE

Gouache and mixed media on paper, 15.5" x 8.75", 2015.

RIGHT PAGE

FROG WIFE'S BAD DAY

Acrylic and collage on board, 6" x 4", 2012.

FROG WIFE'S BAD DAY

FATALES - The Art of Ryan Heshka

ABOVE

ENTOMOLOGICAL SOMNAMBULISM

Acrylic and collage on board, 6.25" x 5.25", 2012.

MEAN GIRLS

ABOVE:
RED BEAVER BANDIT
Acrylic and collage on board,
7.5" x 5.5", 2015.

171

FATALES - The Art of Ryan Heshka

ABOVE
THE ARRIVAL
Oil and collage on paper,
12" x 24", 2013.

RIGHT PAGE
WOMEN OF DEPARTMENT X
Acrylic and collage on board,
8" x 5.5", 2013.

TOP, LEFT
HELLO RADIO BOYS
Acrylic and collage on
panel, 4" x 4", 2014.

TOP, RIGHT
NOW EAT!
Acrylic and collage on
panel, 4" x 4", 2014.

BOTTOM
FAMOUS FOR YEARS
Acrylic and collage on
panel, 4" x 4", 2014.

RIGHT PAGE
SMOKING GIRL
Oil on canvas,
52" x 36", 2016.

MEAN GIRLS

MEAN GIRLS

LEFT PAGE

PUBLIC ART AND BATHING
Acrylic and collage on board,
20" x 16", 2011.

ABOVE

SENSATIONAL FUTURE PLEASURES
Oil and collage on panel,
12" x 12", 2013.

FATALES - The Art of Ryan Heshka

TOP

WIZARD WITH WOMAN
Oil on panel,
11" x 7.5", 2015.

RIGHT PAGE

RETURN OF THE SPIRIT
Oil on panel,
12" x 9", 2014.

178

the SKIN MACHINE

17

14

Heshka

EYES of Glass only

FATALES - The Art of Ryan Heshka

PREVIOUS DOUBLE PAGE, LEFT
THE SKIN MACHINE
Acrylic and collage on board, 4" x 3", 2014.

PREVIOUS DOUBLE PAGE, RIGHT
EYES OF GLASS ONLY
Acrylic and collage on board, 4" x 3", 2014.

ABOVE
BLUE BIRDS
Oil and collage on panel, 11.5" x 9.5", 2015.

RIGHT PAGE
PANTHER WOMAN (WITH FLIES)
Oil on board, 4" x 3", 2016.

MEAN GIRLS

MEAN GIRLS

TOP
MODEL ICE HOMES
Acrylic and collage on board, 5" x 4", 2015.

RIGHT PAGE
COLD WOMAN
Oil on panel, 4.75" x 4.75", 2014.

FATALES - The Art of Ryan Heshka

TOP

EXPERIMENT 769

Acrylic and collage on panel,
10" x 10", 2007
(image courtesy of BLAB!).

BOTTOM

RESIST CONTROL

Acrylic and collage on panel,
8" x 8", 2006
(image courtesy of BLAB!).

186

TOP
BRIDES OF SCIENCE
Acrylic and collage on panel,
12" x 12", 2006
(image courtesy of BLAB!).

BOTTOM
ETC.
Acrylic and collage on panel,
8" x 8", 2006
(image courtesy of BLAB!).

FATALES - The Art of Ryan Heshka

ABOVE

PORTRAIT OF SMOKING WOMAN

Acrylic on paper,
8" x 8", 2006.

RIGHT PAGE

LIGHTS OUT

Oil and collage on panel,
12" x 12", 2015
(image courtesy of BLAB!).

LIGHTS OUT

MEAN GIRLS

FATALES - The Art of Ryan Heshka

PREVIOUS DOUBLE PAGE, LEFT	PREVIOUS DOUBLE PAGE, RIGHT	ABOVE	RIGHT PAGE
SPEED SUPER FREAKS	**OUR FOUNDERS**	**HOCKEY WIDOW**	**THE FLORAL ENTITY**
Acrylic and collage on board, 5" x 4", 2013.	Oil and collage on panel, 40" x 26", 2015.	Oil and collage on panel, 13" x 11", 2015.	Oil and collage on paper, 14" x 11", 2015.

192

MEAN GIRLS

EDMONTON
the FLORAL ENTITY

FATALES - The Art of Ryan Heshka

ABOVE

**THE RAVAGES
OF PINE DISEASE**

Oil and collage on paper,
16" x 11", 2015.

RIGHT PAGE

MYSTERY TWINS #1

Acrylic and collage on panel,
16" x 12", 2010.

194

FATALES - The Art of Ryan Heshka

MEAN GIRLS

197

FATALES - The Art of Ryan Heshka

PREVIOUS DOUBLE PAGE, LEFT
NATURAL ENEMIES
Acrylic and collage on panel,
32" x 28", 2009.

PREVIOUS DOUBLE PAGE, RIGHT
REVOLT (PLANET OF WOMEN)
Acrylic and collage on panel,
22" x 15.5", 2009.

ABOVE
YELLOW HORROR
Acrylic and collage on board,
10" x 10", 2014.

RIGHT PAGE
RAINBOW VISION
Gouache on vintage daytimer,
5.25" x 5.25", 2009.

JANUARY, 1910.

SUN.
2

MON.
3 Came from Detroit
 stormed like
 like the date

TUES.
4

WED.

THURS.
6

FRI.
7

SAT.
8

JANUARY, 1910.

SUN.
9

MON.
10

TUES.
11

WED.
12

THURS.
13

FRI.
14

SAT.
15

Bal in Bank May 3/13 $0.02

FATALES - The Art of Ryan Heshka

ABOVE
FASHION POLICE
Gouache and mixed media on paper, 22" x 9", 2012.

RIGHT PAGE
FASHION POLICE ADVENTURE
Gouache and mixed media on paper, 15" x 11.5", 2013.

MEAN GIRLS

ABOVE
ICE WRESTLING
Gouache and mixed media on
paper, 7.25" x 4.75", 2015.

ABOVE
BRIDES OF THE FROG–MEN
Acrylic and collage on
panel, 10" x 15", 2016.

MEAN GIRLS

BRIDES of The FROG-MEN

FATALES - The Art of Ryan Heshka

TOP, LEFT
GREEN HAIRED GIRL
Oil on board,
6.75" x 4.75", 2014.

BOTTOM
PINK HAIRED GIRL
Oil on board,
6.5" x 4.5", 2014.

TOP, RIGHT
YELLOW JACKET GIRL
Oil on board,
4.25" x 3", 2016.

RIGHT PAGE
BRIDE OF CANADA
Acrylic and collage on board,
3.25" x 2", 2015.

204

MEAN GIRLS

BRIDE of CANADA

10¢

No. 2

FATALES - The Art of Ryan Heshka

MEAN GIRLS

PREVIOUS DOUBLE PAGE, LEFT
IN FLAMES
Oil on board,
4.5" x 3", 2014.

PREVIOUS DOUBLE PAGE, RIGHT
WONDER WIZARD WORLD
Oil on paper,
25" x 15.75", 2014.

RIGHT PAGE
MASTERS OF THE MAN–DOGS
Acrylic and collage on panel,
22" x 27", 2015.

Masters of the Man-Dogs

ABOVE

WINTER FESTIVAL

Oil and collage on panel,
12.75" x 10", 2015.

RIGHT PAGE

CANADIEN HOME MOVIES

Acrylic and collage on panel,
4" x 2.75", 2015.

the

No. 2

THE SHES
Oil on paper,
12" x 24", 2011.

FATALES - The Art of Ryan Heshka

MEAN GIRLS

MEAN GIRLS CLUB
Gouache and mixed media on paper, 7.5" x 15", 2012.

ABOVE

IT'S MY BROW, ISN'T IT?

Gouache on vintage daytimer, 5.25" x 5.25", 2010.

MEAN GIRLS

RIGHT PAGE

MEAN GIRLS CLUB

Installation, mixed media, 2014.

217

FATALES - The Art of Ryan Heshka

ABOVE

MEAN GIRLS CLUB
Short film stills, 2014.

MEAN GIRLS

NEXT DOUBLE PAGE, LEFT

FULVIA AND ULVA PANEL DETAIL, "MEAN GIRLS CLUB" COMIC

Gouache on paper, 2015 (image courtesy of Nobrow).

NEXT DOUBLE PAGE, RIGHT

FULVIA AND ULVA

Oil and mixed media on panel, 18" x 14", 2015.

MEAN GIRLS

FATALES - The Art of Ryan Heshka

PREVIOUS DOUBLE PAGE

SPREAD FROM "MEAN GIRLS CLUB" COMIC

2015 (image courtesy of Nobrow).

TOP LEFT

WENDY

Gouache and mixed media on paper, 8" x 6", 2015.

TOP RIGHT

MCQUALUDE

Gouache and mixed media on paper, 8" x 6", 2015.

BOTTOM LEFT

WANDA

Gouache and mixed media on paper, 8" x 6", 2015.

BOTTOM RIGHT

SWEETS

Gouache and mixed media on paper, 8" x 6", 2015.

RIGHT PAGE

PINKY

Gouache and mixed media on paper, 8" x 6", 2015.

RIGHT PAGE

SPIDER-PINKY PANEL DETAIL, "MEAN GIRLS CLUB" COMIC

2015 (image courtesy of Nobrow).

MEAN GIRLS

PINKY

MEAN GIRLS

BAT-

I have had a lifelong fascination with mysterious, elusive and exotic creatures. My obsessive shopping list includes the giant squid, the praying mantis, rays, sharks and dinosaurs of all shapes and time periods. But none have captured and held my imagination like the bat. A bat sighting always feels like I am witnessing something unique and mythical, despite the fact they are quite common. Seeing these nocturnal hunters in action against the night sky is spellbinding.

I can't recall if it was bats that sparked my interest in Batman or vice versa. Either way, I grew up mesmerized by anything with bat ears. The first word I learned to spell was Batman. The first comics I drew (at age 4) were adventures of the Caped Crusader. I feverishly filled stacks of paper with full-color Batman drawings, stopping only to watch Adam West ham it up in his trademark satin cowl. I tend not to use a lot of existing, fictional characters in my current artwork, with the exception of the Dark Knight. When I do portray Batman, I treat him like a distant, foreign version of himself, somewhat lost in translation. His costume scrambled in weird color combinations, tightly fitted over a male, female or gender-neutral body, awkwardly posed like a well-loved but worn out action figure.

In true evasive form, the bat also remains the most challenging animal for me to draw or paint satisfactorily. I dislike using photo reference to create my art, so reinventing these complex creatures with each new painting can result in hours of edits. The difficulty of successfully capturing the image of the bat adds yet another level to the captivating quality of these flying emissaries of the darkness.

ABOVE
RADIO–CONTROL DEVIL
Acrylic and collage on panel,
6.25" x 9", 2013
(image courtesy of BLAB!).

RIGHT PAGE
GOLLY
Acrylic and collage on board,
10" x 8", 2005.

ABOVE

SAD BATMAN
Gouache on vintage daytimer,
5.25" x 5.25", 2014.

RIGHT PAGE

HERE'S PROOF
Oil and collage on paper,
10" x 14", 2015.

BAT-FETISH

Here's Proof

ABOVE, LEFT
SPANISH BATMAN
Oil on panel,
6" x 6", 2014.

ABOVE, RIGHT
**BAT WOMAN
(YELLOW COWL)**
Pastel on paper,
13" x 10", 2015.

RIGHT PAGE
ONE EYEHOLE
Gouache on vintage daytimer,
5.25" x 5.25", 2008.

BAT-FETISH

FATALES - The Art of Ryan Heshka

PREVIOUS DOUBLE PAGE, LEFT

THE BATMAN #1

Acrylic and collage on panel,
10" x 8", 2008.

PREVIOUS DOUBLE PAGE, RIGHT

THE BATMAN #3

Acrylic and collage on panel,
10" x 8", 2014.

LEFT PAGE

BATWINGS

Gouache and mixed media on paper, 8" x 5.5", 2006.

ABOVE

WONDERS THROUGH THE MICROSCOPE

Gouache and mixed media on paper, 8" x 5.5", 2006.

FATALES - The Art of Ryan Heshka

ABOVE
ASK FOR IT
Acrylic and collage on board,
6.25" x 2.75", 2013.

RIGHT PAGE
NEON BAT SHIT DELUXE
Acrylic and collage on board,
5" x 3.5", 2014.

Neon Bat shit Deluxe

FATALES - The Art of Ryan Heshka

ABOVE, LEFT
GOLLY #2
Acrylic and collage on board,
9.5" x 7", 2005.

ABOVE, RIGHT
GOLLY #5
Acrylic and collage on board,
11" x 7", 2007.

RIGHT PAGE
**ELECTRIC EYE VS.
THERMO WOMAN**
Acrylic and collage on panel,
14.5" x 11.5", 2006.

242

BAT-FETISH

THIS PAGE

GEE BAT

Acrylic and collage on board, 6.75" x 4", 2007.

RIGHT PAGE

BAT GIRLS CLUB

Acrylic and collage on board, 15" x 9", 2011.

NEXT DOUBLE PAGE, LEFT

BAT LADY LOVE

Gouache and mixed media on paper, 5" x 3", 2013.

NEXT DOUBLE PAGE, RIGHT

PINK HAIRED BAT GIRL

Oil on board, 7" x 5", 2015.

BAT-FETISH

FATALES - The Art of Ryan Heshka

BAT-FETISH

AND B

EYOND

FATALES - The Art of Ryan Heshka

I was born with the curious eye. I have always restlessly sought out and dissected new visual stimulus. As a child, I would spend days obsessively filling pages with doodles of sharks, then move on to days of dinosaurs, then Spiderman, and so on. As an adult, I find myself looking at everyday objects with a refreshed eye. I make a concerted effort to see people, nature, and even the most mundane items not as their symbolic forms, but their *true* forms. Their actual shapes, and how those shapes react with each other in space.

Artist Walton Ford said, "We often have contempt for what we are really good at." When I heard this quote it hit home. I constantly seek to push my composition, color palettes, and content. If I get too comfortable with my subject matter, I get bored. I require short-term *and* long-term flux in my art, a sense of always turning a blind corner. Some of my favorite work has emerged from this "lost in the woods" feeling.

Landscapes. Typography. Hockey. Microscopy. Frogs. There is an absurdist side of me that enjoys throwing random subjects together to see what sticks. If I'm surprised by my work, my hopes are that a viewer will be as well. I also mine the dream world when the opportunity presents itself. The irrational quality of dreams is by far the best model for a painting that I can imagine. It is disappointing that I am yet unable to fully render what I experience and see in dreams, but I bring back as much as I can carry.

This chapter represents my efforts to distance myself from pastiche. My goal is always to distill my source material and inspiration down to create work that is personal, unique and singular. My hope is that I never fully reach that goal.

PREVIOUS DOUBLE PAGE
THE AFTERLIFE
Acrylic and collage on panel
12" x 24", 2011.
(image courtesy of BLAB!)

RIGHT PAGE
**MYSTERY CARPET
(DETAIL)**
Oil and collage on panel,
10" x 12", 2013.

NEXT DOUBLE PAGE, LEFT
ICED PAGODA CAKE
Acrylic and collage on panel,
9" x 6.25", 2013.

NEXT DOUBLE PAGE, RIGHT
**AMATEUR TELEVISION
WORLD**
Acrylic and collage on panel,
9" x 6.25", 2013.

TERY CARPET

FATALES - The Art of Ryan Heshka

FATALES - The Art of Ryan Heshka

ABOVE
PREPARE NOW
Acrylic and collage on panel, 11" x 11", 2006.

RIGHT PAGE
SUB-ZERO RADIO MEN
Acrylic and collage on panel, 8" x 8", 2006.

FATALES - The Art of Ryan Heshka

ABOVE, LEFT

MCGEE RADIO CO.

Acrylic and collage on panel, 13" x 7", 2006.

ABOVE, RIGHT

FIVE SKULLS FACTORY

Acrylic and collage on panel, 14" x 9", 2006.

RIGHT PAGE

ONLY ELECTRICITY

Acrylic and collage on panel, 14" x 14", 2006.

256

ABOVE

DON'T GO

Gouache on vintage daytimer, 5.25" x 5.25", 2006.

RIGHT PAGE

CANADIAN MILITARY

Gouache and mixed media on paper, 31" x 22", 2015.

FATALES - The Art of Ryan Heshka

LEFT

HEARTS OF MYSTERY

Gouache and mixed media on paper, 14" x 8", 2013.

RIGHT PAGE

CANADA IN COLOUR

Gouache and mixed media on paper, 14.5" x 10", 2015.

260

AND BEYOND

261

FATALES - The Art of Ryan Heshka

AND BEYOND

TOP
OUR SPRING LINE
Gouache and mixed media on paper, 6" x 80", 2013.

BOTTOM
SUB–HUMAN CITY
Gouache and mixed media on paper, 5" x 19", 2011.

LEFT

MILWAUKEE DREAMS

Acrylic and collage on board, 3.5" x 2.5", 2013.

RIGHT PAGE

TODAY! TODAY! TODAY!

Acrylic and collage on board, 4.5" x 2.5", 2013.

CHEMICAL FACTORY X
Acrylic and collage on paper,
22" x 48", 2013.

FATALES - The Art of Ryan Heshka

ABOVE

THE RATS

Gouache and mixed media on paper, 7.25" x 4.75", 2015.

RIGHT PAGE

FUTURE HOCKEY MOVIES

Acrylic and collage on board, 5" x 4.25", 2012.

IN CANADA

10¢

Future HOCKEY MOVIES

LOTION
Oil on canvas,
57" x 70", 2016.

FATALES - The Art of Ryan Heshka

TOP, LEFT

JAM IT
Gouache and mixed media on paper, 3.75" x 3", 2013.

TOP, RIGHT

SWEETUMS
Gouache and mixed media on paper, 4" x 3", 2013.

BOTTOM, LEFT

UN DO
Gouache and mixed media on paper, 3.5" x 3", 2013.

BOTTOM, LEFT

WE WON
Gouache and mixed media on paper, 4" x 2.75", 2013.

RIGHT PAGE

A MYSTERIOUS ODOR
Gouache and mixed media on paper, 7.5" x 5", 2012.

272

AND BEYOND

FATALES - The Art of Ryan Heshka

PREVIOUS DOUBLE PAGE
INVISIBLE WAVE
Acrylic and collage on board,
3.5" x 5.5", 2012.

ABOVE
4 SUB–MIDGETS
Acrylic and collage on board,
5.5" x 4.5", 2008.

RIGHT PAGE
SO
Acrylic and collage on board,
7" x 5", 2008.

FATALES - The Art of Ryan Heshka

ABOVE

SOAP DISH STUDIES

Pencil crayon on paper,
5" x 5", 2015.

RIGHT PAGE

INTO THE PALE

Oil on canvas,
65" x 55", 2016.

ABOVE

MAGIC RESCUE

Acrylic and collage on board, 5" x 4", 2013.

BIOGRAPHY

Ryan Heshka was born in Brandon, Manitoba, Canada, and grew up in Winnipeg. Fueled by long prairie winters, his childhood was spent drawing, building cardboard cities and making super 8mm films. Early influences that persist to this day include antiquated comics and pulp magazines, natural history, graphic design, music, movies and animation. Formally trained in interior design, he is self-taught as an artist. Heshka's personal artwork has graced the cover and interiors of *BLAB! magazine* and numerous art publications around the globe, and his paintings have been exhibited in galleries across North America and Europe. *Mean Girls Club*, his first professionally published comic book, was released in 2015 by Nobrow (UK). His illustration work has appeared in *Vanity Fair*, *Playboy*, *Esquire*, the *New York Times* and the *New Yorker*, and he has had two children's books published by Henry Holt and Company (New York). He lives in Vancouver, B.C., Canada with his wife Marinda, daughter Roxy and their cat Louis.

EXHIBITIONS

SOLO EXHIBITIONS

2016
"Mean Girls Club mini show", Floating World; Portland, OR

2015
"Romance of Canada", Antonio Colombo Arte Contemporanea; Milan, Italy

2014
"Mean Girls Club" (installation), Wieden + Kennedy; Portland, OR

2013
"Strange Powers 3", Copro Gallery; Santa Monica, CA
"Teenage Machine Age", Antonio Colombo Arte Contemporanea; Milan, Italy

2012
"Disasterama", Roq La Rue Gallery; Seattle, WA
"Ours", Antonio Colombo Arte Contemporanea; Milan, Italy

2011
"Instinction", Roq La Rue Gallery; Seattle, WA
"Strange Powers 2", Copro Gallery; Santa Monica, CA

2010
"Super Things", Roq La Rue Gallery; Seattle, WA
"Strange Powers", Rotofugi Gallery; Chicago, IL

2009
"Envirus", Roq La Rue Gallery; Seattle, WA
"Electro-Wonders", Harold Golen Gallery; Miami, FL

2008
"The OBIT Paintings", Copro Gallery; Santa Monica, CA
"Radio Science Funnies Inc.", Secret Headquarters; Los Angeles, CA

2007
"Solo Show", Roq La Rue Gallery; Seattle, WA
"Neo-Pulp", Orbit Gallery; West New York, NJ
"Jolly Gleetime", DVA Gallery; Chicago, IL

2006
"Radio Show", JEM Gallery; Vancouver, B.C.
"Solo Show", Roq La Rue Gallery; Seattle, WA
"ABC SpookShow", El Kartel; Vancouver, B.C.

2005
"Humanitarium", Parking Spot Gallery; Vancouver, B.C.
"Robotus Deluxe", DVA Gallery; Chicago, IL
"Solo Show", Roq La Rue Gallery; Seattle, WA
"The Small Show", Columbia Street Gallery; Vancouver, B.C.

2004
"Miss Universe", El Kartel; Vancouver, B.C.

SELECTED GROUP EXHIBITIONS

2017
"HEY! Gallery Show #1", Galerie Arts Factory; Paris, France

2016
"the BLAB! Show", Copro Gallery; Santa Monica, CA
"Don't Wake Daddy 11", Feinkunst Krüger; Hamburg, Germany
"The Hours of Silence", Gallery House; Toronto, ON
"Arcana", Red Truck Gallery; New Orleans, LA

2015
"Post It Show", Giant Robot, Los Angeles, CA
"EXPO", Antonio Colombo Arte Contemporanea; Milan, Italy
"Don't Wake Daddy 10", Feinkunst Krüger; Hamburg, Germany
"500 Show", CG2 Gallery; Nashville, TN
"HEY! Exhibition #2", Halle Saint Pierre; Paris, France
"One Page", Roq La Rue Gallery; Seattle, WA
"Twenty Years Under the Influence of Juxtapoz", LA Municipal Art Gallery; Los Angeles, CA
"Peep Show", Stranger Factory; Albuquerque, NM

2014
"Don't Wake Daddy 9", Feinkunst Krüger; Hamburg, Germany
"One Year Anniversary", Atomica Gallery; London, England
"Sonic", SCOPE Art Fair Miami; Miami, FL

2013
"Don't Wake Daddy 8", Feinkunst Krüger; Hamburg, Germany
"Other Worlds", Roq La Rue Gallery; Seattle, WA
"The Beast Within", Tory Folliard Gallery; Milwaukee, WI
"Northern Lights", Rotofugi Gallery; Chicago, IL

2012
"Don't Wake Daddy 7", Feinkunst Krüger; Hamburg, Germany
"the BLAB! Show", Copro Gallery; Santa Monica, CA
"Post It Show", Giant Robot, Los Angeles, CA
"Group Exhibition: Antonio Colombo Arte Contemporanea", ArtFirst Art Fair; Bologna, Italy
"Twin Peaks: Fire Walk With Me", Copro Gallery; Santa Monica, CA

2011
"Krampus (a BLAB! show)", Roq La Rue Gallery; Seattle, WA
"End of Days", Copro Gallery; Santa Monica, CA
"Power Punch", Giant Robot, Los Angeles, CA
"In the Trees: Twin Peaks 20th Anniversary show", Clifton's Brookdale; Los Angeles, CA

"Vancouver Artists", Interurban Gallery; Vancouver, B.C.
"Post It Show", Giant Robot, Los Angeles, CA

2010
"Don't Wake Daddy 5", Feinkunst Krüger; Hamburg, Germany
"the BLAB! Show", Philip Slein Gallery; St. Louis, MO
"Survey Select", Wonder Bread Factory, San Diego, CA
"Neo-Fabulists", Feinkunst-Krueger; Hamburg, Germany
"Lush Life 2", Roq La Rue Gallery; Seattle, WA

2009
"True Self", Jonathan Levine Gallery; New York, NY
"Lush Life", Roq La Rue Gallery; Seattle, WA
"End of Days", Copro Nason Gallery; Santa Monica, CA

2008
"Don't Wake Daddy 3", Feinkunst Krüger; Hamburg, Germany
"Mark Murphy Art Basel Show", Art Now Fair; Miami, FL
"Anniversary Show", Roq La Rue Gallery; Seattle, WA
"BLAB! A Retrospective", Kansas State University, Marianna Kistler Beach Museum of Art; Manhattan, KS
"Sideshow", Merry Karnowsky Gallery; Los Angeles, CA

2007
"Mark Murphy Art Basel Show", Art Now Fair; Miami, FL
"Don't Wake Daddy 2", Feinkunst Krüger; Hamburg, Germany
"the BLAB! show", Philip Slein Gallery; St. Louis, MO
"the BLAB! show", Copro Nason Gallery; Santa Monica, CA

2006
"Don't Wake Daddy", Feinkunst Krüger; Hamburg, Germany
"the BLAB! Show", Copro Nason Gallery; Santa Monica, CA
"Everything but the Kitschen Sync", Jesus La Luz Gallery; Los Angeles, CA

2005
"Medium Rare", Columbia Street Gallery; Vancouver, B.C.
"Group Show", ArtHouse60 Gallery; Zionsville, IN
"Everything but the Kitschen Sync", Jesus La Luz Gallery; Los Angeles, CA
"Modern Love", M Modern Gallery; Palm Springs, CA
"Annual Tiki Show", New Tiny Gallery; Vancouver, B.C.

2004
"The Pin Up Show", Roq La Rue Gallery; Seattle, WA
"Predicta", Columbia Street Gallery; Vancouver, B.C.

FATALES - The Art of Ryan Heshka

ABOVE
ROBIN IS DEAD
Circa 1976

"I AM FASCINATED BY THE IMPACT OF EVENTS AND VISUALS FROM MY CHILDHOOD."

An interview with Ryan Heshka by Monte Beauchamp, founder of BLAB!

Ryan, you are wearing so many hats these days. There's Heshka the fine arts painter, Heshka the editorial illustrator, and of late, Heshka the comic book artist. If you could cast all financial need aside, under which of these hats would your passion predominately reside?
My response is really dependent on what day of which week I answer the question. One project or experiment will often inform another, and I value all the work that enters and exits my studio. And at the moment, there's nothing better than being able to tag team between painting and my graphic novel, which allows me to look at each project with a fresh eye. But to give you a straight answer, I would have to choose painting/single image creation as my passion. I have always been drawn to the lone image and its imagined narrative. Even in comics, I would often single out a compelling panel and dwell on it, casting the story aside. There are so many genres and art forms that I love—such as film, comics, design, architecture, and fashion—and painting often allows me to funnel many of them into one image. The freedom to answer to my inner voice with color is another reason I consider painting my main focus.

I don't consider myself a comic artist, but comics have always been my favorite "hobby art." Since I was four years old, I have been making comics in some form or another for my own amusement. It wasn't until 2015 that I had a comic professionally published (*Mean Girls Club*, Nobrow Press). But even it grew out of a gouache sketchbook rendering of an angry girl with a unibrow, which was first expanded into an entire art installation. So, in the end, it all comes down to the single image, the painting, the idea.

Perhaps your infatuation with captured moments began by looking though the 8mm film camera lenses and microscopes of your youth; might that have influenced your perception or altered your way of seeing?
I would say the use of the super 8mm camera and the microscope were *extensions* of my interest in drawing and capturing the outside world. As an eight or nine-year-old, the combination of seeing a *Star Wars* TV special revealing how the stop-motion sequences were made *and* obtaining an 8mm camera from my grandpa got me all heated up about animation and special effects. In addition, what I saw through the lens of an uncle's hand-me-down microscope blew my mind and opened me up to how layered our world is. I was mesmerized by the textures and varieties of life in common pond water, and my fantasy project was to shoot a stop-motion film re-creating the world of the pond, with mock-microscopic shots and animated protozoa. To this day, I occasionally dream in microscopic vision.

I wore that 8mm camera out, shooting all kinds of projects: stop motion/claymation, paper cutouts, flip books, live action, and Batman parodies. There is a wonderful textured, wonky quality to 8mm film that I fell in love with as a kid: grainy happy accidents, light leaks, and odd croppings. I shot my *Mean Girls Club* short film for a 2014 art installation on super 8mm; I couldn't bring myself to go digital.

Recently in my paintings, I have been pursuing spontaneous, natural framing, and the beauty and complexity of texture. I spent years "perfecting" composition, following the rules of thirds, avoiding all the usual pitfalls and mistakes of image-making. However, after a lifetime of learning the rules, I am breaking it all back down again, creating with minimum self-consciousness so that my line, texture, and color can really live again.

How did you make the segue from editorial artist into the Pop Surrealism world?
It was through my continued exposure to editorial illustrators early in my career. Then, as now, many artists working commercially were expressing themselves with exhibitions of their personal work. Creating a separate body of self-driven work represented an exciting and rewarding challenge to me. As much as I enjoyed commissioned illustration, the nerd in me had a backlog of weird ideas and techniques I wanted to experiment with. At the same time, I began to discover incredible artists outside the illustration world:

Marcel Dzama, Neo Rauch, Henry Darger. Around 2004, I really got to work on my personal art, coming to the game a bit late at age 34.

There were three events that really propelled me forward. First was forming a collective with several Vancouver illustrators called the "Jupiter Project." We staged local exhibitions, talked art and illustration over drinks, and most importantly, exchanged ideas. Second was meeting my future wife Marinda, a model for one of my early solo shows of pin-up art. From the start, she was super-supportive of my art endeavors and became my inspiration and advisor/voice of reason on the business end. Third was submitting several unsold pin-up pieces to Seattle's Roq La Rue Gallery, which were accepted by founder Kirsten Anderson for a forthcoming group show, which was my first foray into the Pop Surrealism/Lowbrow movement. To have work accepted by the gallerist who popularized the term "Pop Surrealism" was a big feather in my cap.

I never had any big designs to be a part of that world. It was just where my work seemed best suited at the time, where illustrators could showcase their own personal visions. Things are different now, with many of the artists enjoying large retrospectives in world-class museums. The classification seems to have splintered, with sub-genres and movements under the Pop Surrealism umbrella. I'm not sure the term is still in use anymore.

In the final lap of completing a painting, do you ever begin to doubt it?

Yes, often right up to the completion, and even then sometimes I have to look at a finished painting several weeks later before I know it's "finished." But most of the doubt occurs in the middle of the painting, while I'm balancing light, colors, etc. All I can do is power through and trust that I will be able to solve the problems in the painting.

Have you ever destroyed a painting you started out excited about? What are the feelings such an experience drums up?

Yes, and I find myself increasingly doing this. I have tried to detach myself from the feeling of "I have put days into this, so I can't start over," and focus on whether or not the end result will be a worthy entry in my catalogue. Out of the five large sized canvases I have been working on in the past year, two of them were false starts. There is a sense of disappointment at first, which quickly gives way to the excitement of a fresh start.

When painting a personal piece, do there remain mysteries in your own working process?

Absolutely. I am not an artist who has a clear workflow, producing many works that focus on one subject or treatment. Because of that, I leave the flow open to experimentation, and sometimes textures and effects show up that were not intended. But if they work, I leave them in and they become part of the life of the piece.

Did your gallery style grow out of your illustration work, or did your illustration style grow out of your gallery work?

Gallery style from illustration work. Although I think my personal work really came from all of the art forms that I loved well before I was an illustrator.

Are there specific ways in which each influences your work as a comics artist?

I try to bring the energy of my personal work to the panels, but the discipline of illustration keeps me on schedule. Being used to answering to a timeline has helped me when trying to get comic work completed.

Your twenties versus your thirties—which period do you deem most crucial to your development as an artist?

Thirties, hands down. My twenties were spent floundering around trying to figure myself out. Not wasted time, but not

the most efficient decade of my life! My thirties by contrast was super productive, and I became much more curious.

Self-taught versus trained. What are your thoughts?
Personally, I have missed out on the mentorship of instructors and camaraderie of the classroom in terms of my art (although I did have that in interior design). But I feel that with the formalness of education can come an assembly line mentality, going through the motions of classes and studios, and if you are not self-driven, NOTHING is going to help you launch an art career.

On your path to becoming a painter, did making a living get in the way?
Luckily, no. My wife Marinda has been with me since I began my personal art, and she not only has supported me but has acted as a business partner, accountant, sounding board, and cheerleader. I have been fortunate to be able to balance illustration (bread and butter) with my personal work (heart and soul), with someone amazing behind me to make it possible.

Gloom and doom are key motifs in much of your work, yet you claim to have had a wonderful upbringing. Was there anything unsteady in your childhood you're not telling us about?
Really, my childhood was idyllic. I just have always had a bit of a dark side. Fortunately, this was balanced with a sense of humor and appreciation for beauty. I think much of this dark imagery comes from my fascination with pulps, films, comics. I guess I'm lucky I can live out my dark side in art.

In your paintings do you confront or reflect?
I don't consciously confront, but I do reflect more and more lately. Reflect feelings from childhood, what I see in the world, my hopes and disappointments. Without trying too hard, I attempt to let my art naturally reflect myself and I try to be open to what forms that may take on. These are things I'm exploring at the moment.

Is there ever a struggle in getting started on a personal painting? How do you lessen the distance between thinking and doing?
That struggle exists weekly. I can easily talk myself out of starting a painting for dozens of reasons. The doubt and hesitation can increase with the size of the piece. I have found that spending a day experimenting prior to starting a piece helps tremendously. Sometimes concepts and layouts present themselves in a stream of consciousness fashion if I'm not focused on the "final." Also, just practicing techniques like color mixing can open up the gates.

Is there a particular brand of alcohol you like to kick back with?
Depends on the season, but I picked up a fondness for Campari in Italy.

What's Ryan Heshka's idea of a rockin' good time?
Traveling to Europe, seeing friends and meeting new ones, talking art and drinking and eating. This is something I always look forward to doing. I love spending time in Europe. Even the simplest thing like sitting at a cafe in a public square listening to church bells becomes an incredible experience. I think my true party days are well past me. Now I can use my baby as an excuse to stay in.

Based on your normal upbringing, might the fetishistic nature of *Fatales* cause your mom and pop some worry? Upon viewing your piece *Pubic Spy*, even I thought, "What the ??? What has Ryan gotten himself into?"
Ha! That's a Glenn Bray commission. Yes, I don't doubt that my parents might not be too enthusiastic about many of my images. I come from a pretty religious and conservative family background. For a while I used to worry about what all my relatives might think, but I got over that feeling of stifling myself. Still, I don't wish to paint myself into a corner of fetish art. I'm trying to put some distance between myself and that type of content.

Does music play a part in the creation of your personal work? What do you listen to?
Music acts as the soundtrack to what I see in my head, so the selection of audio on any particular day is pretty key. I listen to a wide range of music. Film soundtracks (*Citizen Kane*, *King Kong*, Angelo Badalamenti scores for David Lynch films), jazz and blues (Fats Waller, Louis Armstrong, Bessie Smith, Robert Johnson), and contemporary electronica (Caribou, Crystal Castles, Electric Youth, Röyksopp, Miss Kitten) are the main genres. For sheer variety and obscureness, I listen to *Chances With Wolves* mixes, which feature the weirdest assortment of covers and old songs you could imagine. Lately I have been revisiting music from the 4AD label that I listened to in college, like The Breeders and This Mortal Coil. I also have a big collection of old radio shows that get heavy rotation, *Lights Out* being my favorite.

You're a connoisseur of the early pulp and comic magazines. Who were the Golden Age painters and cartoonists that floated your boat?
So many artists! For pulp painters: Frank R. Paul, H.J. Ward, Norm Saunders, the Rozen Brothers, Margaret Brundage, H.W. Wesso, "JO" (an obscure artist who did a handful of covers), J. Allen St. John. Cartoonists: Tarpé Mills, Bill Everett and Carl Burgos (I really like the Funnies Inc. roster), Basil Wolverton, Jack Kirby, Chester Gould, Bob Kane, Fletcher Hanks, Bob Davis, Jack Cole, Lou Fine. There are so many, but these are the ones that come to mind immediately.

To paraphrase an individual you greatly admire, David Lynch, every time a person does something such as painting, the past can conjure those ideas and color them. Even if they are seemingly new ideas. Comments?
Lately, I find myself thinking about how my past experiences, especially from my childhood, continually creep into my work. I am fascinated by the impact of events and visuals from my childhood, and how vivid those visuals remain. Sometimes it feels like currently I am continuing or finishing ideas and thoughts that started as a kid, trying to capture that feeling of discovery.

You've experienced a few disconcerting episodes with gallerists. Does the emotional turmoil from such an experience sideline you or does it help you to create?
These relatively few experiences have always been totally business oriented, but I end up taking them very personally. I have difficulties separating my art from the business end of things, and usually it shuts me down for a few days. Time, and my wife talking me down from the ledge help me to see it for what it is: business. I don't think it has ever helped me create; I see it as more of a nuisance, an unwanted distraction.

I've noticed that with many professional illustrators and painters, their nails are bitten down. Ryan, how are your nails?
I have been trying to break that habit for years. But at least I'm in good company.

Your paintings are defined by your remarkable skill as a draftsman, but does that ability ever get in the way of the process of painting? Joe Coleman, for example, does no preliminary work. He'll start working on a corner of a masonite slab and the painting will take on a life of its own. Do you anticipate the day when you'll eliminate your preliminary phase completely?
Yes and yes. For me, over-preparation can suck the life out of a painting. To counter this, I have sketchbooks dedicated to spontaneous image-making. I set aside as much time as I can to experiment in these books, which really frees my mind and loosens my hand. That's when new ideas and new visual language starts to flow. For my current body of paintings, which are much larger than usual, I have reduced the amount of preliminary work down to small, simple pencil-crayon sketches, which serve as the springboard. I'll have an idea of composition, values, and forms, but I will mostly let myself figure it out and

react to the visuals while painting at full scale. I feel that I can't create a satisfactory tight layout at a small size, then blow it up 900%, trace it on canvas, and have it translate well at a larger size. All the mistakes get amplified. The positive and negative space requirements change. Things start to stiffen up. The work will be fresher if I can react and respond at the composition's actual size.

Eventually, I will get to the point where I paint directly on the canvas at full scale, without any preliminary work. But like other evolutions in my art, I dip my toes in slowly.

Is there any particular painting that marked a turning point for you?
Two come to mind: the first is *Golly*, painted in 2005, about a year and a half into my personal painting. This was the first time I had painted an image that came in a dream. It hit the right notes for me and gained some distance from the cartoony paintings I was doing. I still recall your comments about how you liked that the human faces were all turned away from the viewer and I feel this painting was my unofficial ticket into *BLAB!*, and a wider audience. It made me realize I was onto something.

The second is *Into the Pale*, a private commission completed in 2016. The x-shaped picket fence and garden is also based on a dream (about my grandma's backyard). It was not only my largest oil painting up until that point, but marked a big departure from the comic/pulp/pin-up type imagery that I am well known for. I tried to think about objects more in terms of their psychological properties. That piece also marked the beginning of a much more spontaneous, organic art-making process. Lots of growing pains with that one.

The sketchbook plays a major role in your ideation process. What role does imagination play? Does an image ever pop into your head out of the blue or is it always born out of sketching? For example, Keith Richards of the Rolling Stones claimed the song *Satisfaction* came to him while in a dream. Any similar experiences? Also, does your vast collection of comics and pulps inspire ideas?
The majority of the time, the ideas arrive from sketching. Sketching random shapes or objects I see day to day, or imagined people, or color combinations I see or come up with. Anything goes. The sketchbook acts as a depository that I can draw from, a pantry of partial ideas. I still reference sketchbooks from years ago, as they can potentially contain the right sketch of a plant or shoe or whatever fits the painting I have on the go. Sometimes fully incubated ideas do present themselves, but this is rare. It's gold when that happens, and the idea quickly gets entered in a sketchbook before it disappears back into the ether. Similarly, a compelling scene or detail or mood will come to me in a dream, and I wake up and make a quick sketch with notes to capture as much as I can remember. The paintings that come from dream imagery are among my personal favorite work, as they feel the most pure and raw. They are not influenced directly by an outside source. Capturing that dream imagery satisfactorily is the challenge.

A "vast collection" is a generous overstatement! I have a modest sized collection. Comics and pulps used to factor heavily as inspiration, but in the past few years my interest has been in creating more unique, original work, honing my vision. Of course, comic language is still at the root of my drawings, but the imagery I create is growing away from the original pulp sources.

FATALES
The Art of Ryan Heshka

ABOUT THE CONTRIBUTING AUTHOR:
Monte Beauchamp is the founder, editor, and designer of *BLAB!, BLAB WORLD*, and the *BLAB! Picto-Novelette* series. His books include *Masterful Marks: Cartoonists Who Changed the World* (Simon & Schuster), *The Life and Times of R. Crumb* (St. Martin's Press), and *Krampus: The Devil of Christmas* (Last Gasp Books). In 2012, Beauchamp was awarded the Society of Illustrators' prestigious Richard Gangel Art Director Award.

SPECIAL THANKS TO:
Marinda and Roxy Heshka, Joan and Lorne Heshka, Tyler and Amanda Heshka, Jodi Epps and John Epps.

Benjamin Brard (book designer) and Rodolphe Lachat (editor) at Cernunnos.

Kirsten Anderson, Sam Arthur, Alex Spiro and the staff at Nobrow, Monte Beauchamp, Antonio Colombo, David and Ana at colección solo, Bruce and Pablo at El Cartel, Greg Escalante, Harold Golen, Anne, Julien and Zoe at HEY! Magazine, Liane Varnam and the Jupiter Project, Kate Larkworthy, Mark Murphy, Christy Ottaviano, Gary Pressman, Marion Peck and Mark Ryden, Harry Saylor, Fred Stonehouse, David Van Alphen, and the many inspiring artists, gallerists, friends and fans who have supported my art.

First published in 2017 by CERNUNNOS
An imprint of Dargaud
15/27, rue Moussorgski
75018 Paris
www.cernunnospublishing.com

ISBN: 9782374950495

© 2017 Ryan Heshka
www.ryanheshka.com
Texts: respective authors

All rights reserved. No part of this publication may be reproduced, stored in a retrieval system, or transmitted in any form or by any means, electronic, mechanical, photocopying, recording, or otherwise, without prior consent of the publisher.

2016 2017 2018 2019 2020 / 10 9 8 7 6 5 4 3 2 1

Director of publication: Rodolphe Lachat
Cernunnos logo design: Mark Ryden
Book design: Benjamin Brard

Cover: Pink Haired Bat Girl (detail) - oil on board – 7" x 5" – (2015)
Backcover: Into The Pale – oil on canvas - 65" x 55" – (2016)

Dépôt legal: novembre 2017

Printed in Italy